BEVERLY MASSACHUSETTS

illustration school:
let's draw plants and small creatures

sachiko umoto

QUARRY BOOKS

First published in the United States of America in 2010 by
Quarry Books, a member of
Quayside Publishing Group
100 Cummings Center
Suite 406-L
Beverly, Massachusetts 01915-6101
Telephone: (978) 282-9590
Fax: (978) 283-2742
www.quarrybooks.com
Visit www.Craftside.Typepad.com for a behind-the-scenes peek at our crafty world!

Library of Congress Cataloging-in-Publication Data

ISBN-13: 978-1-59253-647-4
ISBN-10: 1-59253-647-6

10 9 8 7

Printed in China

to the reader

They say that "learning begins by "imitating," so I have filled this book with a lot of illustrations that you can draw by copying. Take your time, look at each illustration one by one, then choose one you like and try tracing or drawing one yourself. Your drawing doesn't have to turn out just like the example, so don't worry if it doesn't turn out exactly the same. Think about how you would draw the picture and arrange its parts any which way you choose!

The trick to enjoying illustration is showing your work to other people. "Don't you think this is cute?" "This is really funny-looking, isn't it?"

Ask your family and friends these questions when you show them your drawings. If even a little bit of what you wanted to express gets across to them each time you show them a drawing, there is no doubt that illustrating will become more and more fun.

Work at your own pace, when you want, where you want. But whatever you do, try your hand at creating a whole bunch of really cute drawings, OK?

Sachiko Umoto

how to enjoy this book

1

choose one
Look for your favorite character. Ask your friends and family what characters they like.

2

imitate it
Look at the page on the left and use the guide to casually trace what you see.

3

modify it
Try changing the expression of your drawing. You can make different poses, or add different colors.

4

show it
Show your friends and family the pages you have doodled on, or the notebooks and memo pads you have drawn on.

drawing tools and paper

Pencils and Mechanical Pens

If you make a mistake, you can just erase it, so you can draw anything in any way you choose. Apply different pressures to your pencil tip to get a diverse array of lines

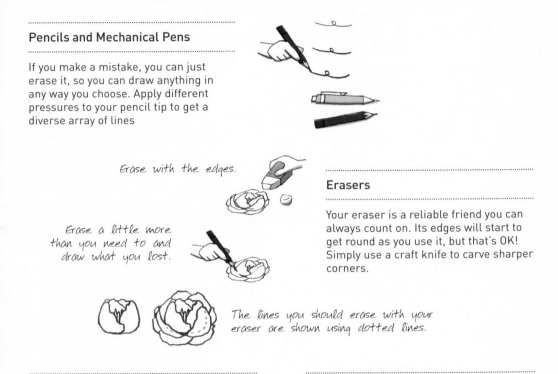

Erase with the edges.

Erase a little more than you need to and draw what you lost.

Erasers

Your eraser is a reliable friend you can always count on. Its edges will start to get round as you use it, but that's OK! Simply use a craft knife to carve sharper corners.

The lines you should erase with your eraser are shown using dotted lines.

Ballpoint Pens and Felt-Tipped Markers

Try drawing the entire picture at once. You won't be able to erase your mistakes, but you can draw things pretty quickly.

Colored Pencils and Colored Felt-Tipped Markers

Coloring can also be a lot of fun. You don't have to color the entire picture. Leave some white space. Wrapping up your drawing with just a few colors can add a really nice finish.

Notebooks, Appointment Books, Memo Pads, Etc.

You can use whatever you can find around you for your canvas. And I recommend doodling, as long as your doodles don't interfere with your studies or your work.

the basics of the basics

Learning some basic skills helps make drawing easy. But, remember, the basics are nothing more than a fundamental starting point.

1. Draw larger shapes first

Draw the head before you draw the eyes or the nose, draw the body before you draw the hands, feet, or other patterns. Try to get a idea of the overall shape before you add the fine details.

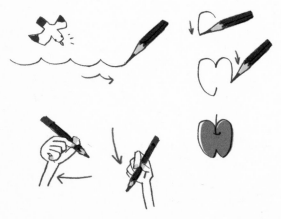

2. Draw from top to bottom, right to left

Pick up your pen or pencil and try waving it around. Can you feel how natural it is to move it from top to bottom or right to left? (Or left to right, if you are left-handed!)

3. Draw the head before you draw the body

When you draw the head, you can get a feel for your character's personality and what it is probably thinking at the time. This makes it easier for you to decide how to draw the rest of the body

The Basics Can Be Contradictory

Sometimes the basics described in steps 1, 2, and 3 will seem to contradict each other, and you may have a hard time deciding where to start. If that is the case, just start wherever you want.

After drawing the leaves, draw the lotus

After drawing the lotus, put them together

4. Apply different pressures to the tip of your pen

Press hard when you draw the solid parts and lightly when you draw the soft parts. You can draw a lot of different lines with the same pen just by applying different amounts of pressure.

Press down hard

Gentle and fluffy

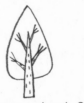

Leave uncolored

Gently shade with gray

Color in strong black

illustration school with plants and small creatures

contents

2 to the reader
3 how to enjoy this book
4 drawing tools and paper
5 basics of the basics

10 introduction: drawing songs
12 the little bee song
14 the little miss sunflower song
16 the cactus kid song
18 the madame butterfly song
20 the little miss tulip song

22 making characters

24 chapter 1 spring, summer, autumn, and winter in the forest
26 cherry blossoms/ rape blossoms
28 plum trees/ butterbur flowerbuds
30 tulips/ daisies
32 pansies/ violets
34 anemones/ hyacinths
36 camellias/ peonies
38 roses/ lilacs
40 ants/ dandelions
42 carnations/ poppies
44 swallowtail butterflies/ primroses
46 lilies-of-the-valley/ lilies
48 chinese lantern plants/ praying mantis
50 hydrangeas/ swallows
52 water lilies/ ornamental carp
54 marguerite/ wild strawberries
56 lavender/ chamomile
58 sunflowers/ morning glory
60 rhinoceros beetles/ stag beetles

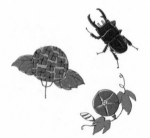

**82 chapter 2 a harvest festival
of fruit and vegetables**

84 apples/bananas
86 strawberries/lemons
88 cherries/grapes
90 a pineapple/ a watermelon
92 carrots/pumpkins
94 tomatoes/ cabbages
96 corn/asparagus
98 melon/ pears

100 illustrations on stationery

106 epilogue gallery

112 about the author

62 hibiscus/ palm trees
64 frogs/ fireflies
66 autumn maple trees/ salvia
68 maple trees/ cosmos
70 ginkgo trees/ pampas grass
72 akebi vines/ red spider lilies
74 konara oak trees/ acorns
76 chestnuts/ chestnuts in burrs
78 christmas trees/ poinsettias

80 flower arrangement

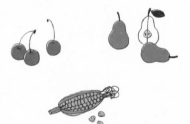

introduction: drawing songs

singing while drawing helps you draw good and strong lines

the little bee song
the little miss sunflower song
the cactus kid song
the madame butterfly song
the little miss tulip song

the little bee song

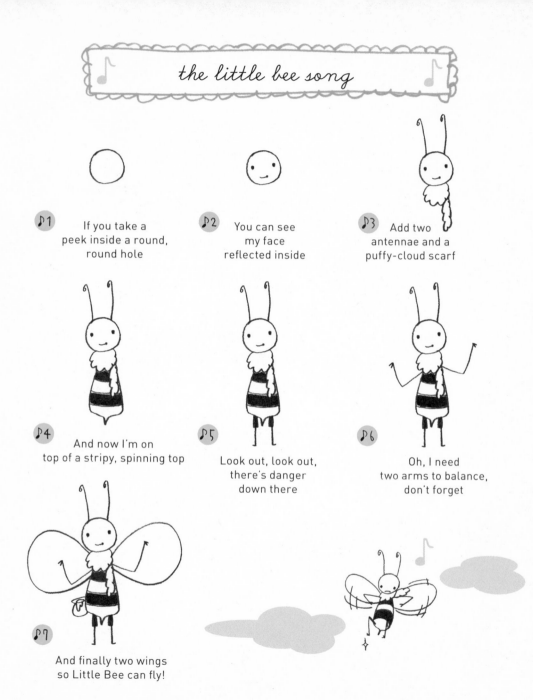

♪1 If you take a peek inside a round, round hole

♪2 You can see my face reflected inside

♪3 Add two antennae and a puffy-cloud scarf

♪4 And now I'm on top of a stripy, spinning top

♪5 Look out, look out, there's danger down there

♪6 Oh, I need two arms to balance, don't forget

♪7 And finally two wings so Little Bee can fly!

let's draw!

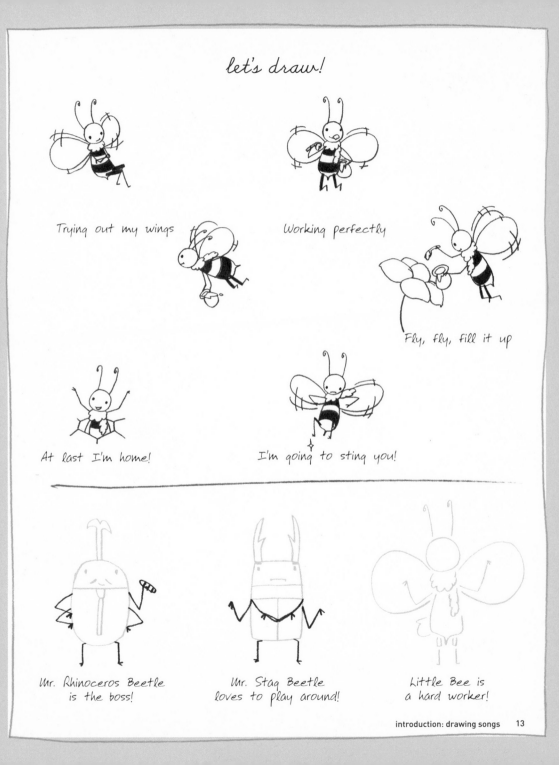

Trying out my wings

Working perfectly

Fly, fly, fill it up

At last I'm home!

I'm going to sting you!

Mr. Rhinoceros Beetle
is the boss!

Mr. Stag Beetle
loves to play around!

Little Bee is
a hard worker!

the little miss sunflower song

♪1 Guess what, I've found a secret hole

♪2 If you quietly take a look inside

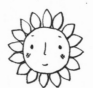

♪3 Fireworks burst out with a bang

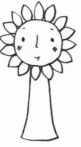

♪4 Feeling so happy I blow on a trumpet

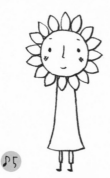

♪5 Tra-la-la, music notes jump up and down

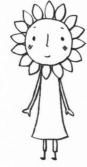

♪6 Ribbons are swaying in the wind

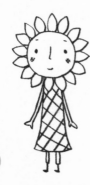

♪7 And Little Miss Sunflower looks so chic in her dress

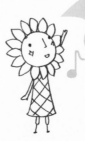

let's draw!

Nice to
meet you.

Oh dear!

Sob, sob

I'm in a
good mood.

Please
grow
for me.

I love
the sun.

Miss Dandelion
is rather shy!

Little Pansy
is a little precocious!

Little Miss Sunflower
is cool and chic!

the cactus kid song

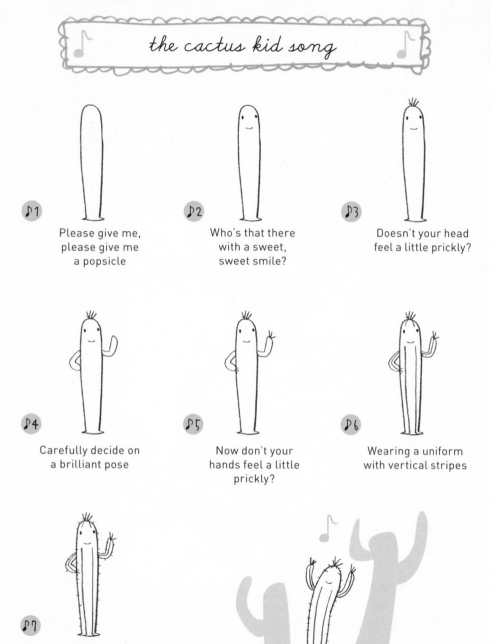

♪1 Please give me, please give me a popsicle

♪2 Who's that there with a sweet, sweet smile?

♪3 Doesn't your head feel a little prickly?

♪4 Carefully decide on a brilliant pose

♪5 Now don't your hands feel a little prickly?

♪6 Wearing a uniform with vertical stripes

♪7 The Cactus Kid appears after all the prickles are drawn!

let's draw!

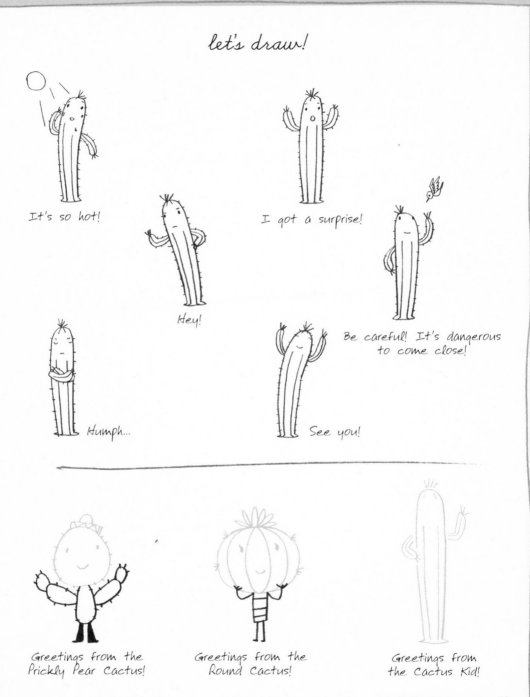

It's so hot!

Hey!

I got a surprise!

Be careful! It's dangerous to come close!

Humph...

See you!

Greetings from the Prickly Pear Cactus!

Greetings from the Round Cactus!

Greetings from the Cactus Kid!

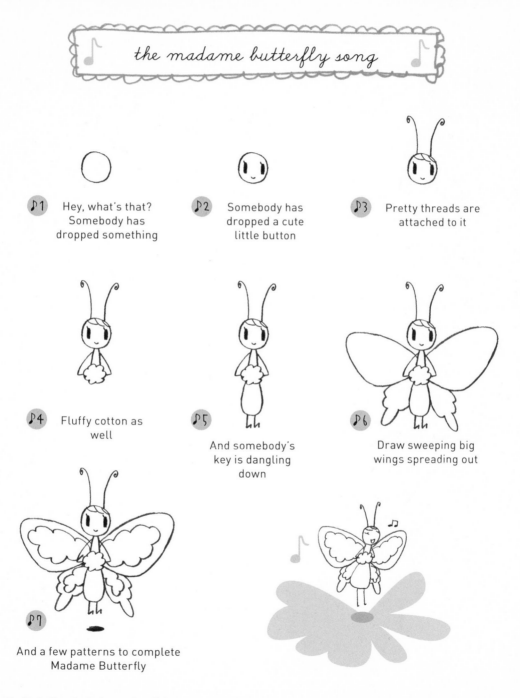

the madame butterfly song

♪1 Hey, what's that? Somebody has dropped something

♪2 Somebody has dropped a cute little button

♪3 Pretty threads are attached to it

♪4 Fluffy cotton as well

♪5 And somebody's key is dangling down

♪6 Draw sweeping big wings spreading out

♪7 And a few patterns to complete Madame Butterfly

let's draw!

Oh! Rain!

Fluttering

Taking a break

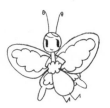

A timid smile

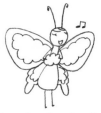

La, la, la, la, la

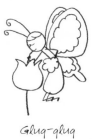

Glug-glug

Mr. Ant, the waiter Avid reader, Mrs. Ladybug Elegant Madame Butterfly

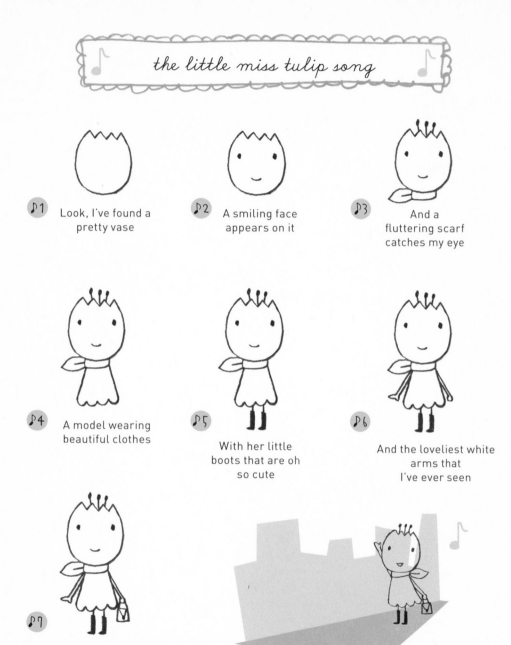

the little miss tulip song

♪1 Look, I've found a pretty vase

♪2 A smiling face appears on it

♪3 And a fluttering scarf catches my eye

♪4 A model wearing beautiful clothes

♪5 With her little boots that are oh so cute

♪6 And the loveliest white arms that I've ever seen

♪7 Give her a bag for the finishing touch— Little Miss Tulip

let's draw!

That looks tasty

I've had enough!

In her own world

Eek!

Hi!

La, la, la

Hello, Little Miss Lily

Hello, Little Miss Cherry Blossom

Hello, Little Miss Tulip

making characters

Let's try making flowers, fruits, trees, and insects into characters by drawing their faces, arms, and legs. By adding poses and expressions you can fill the characters with plenty of humor and transform them in many ways.

flower characters

I was wondering what kind of clothes they should wear...

In this case, I decided to try and draw clothes in the shape of petals.

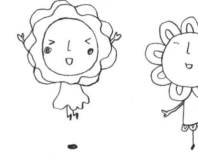

fruit characters

I imagined the personalities of each character and designed clothes that I thought would suit them.

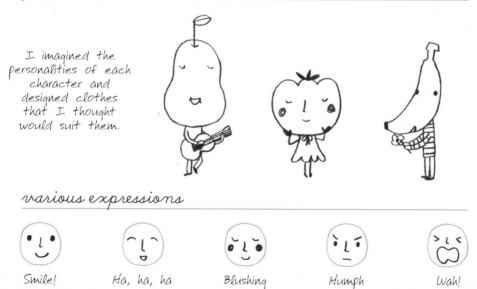

various expressions

Smile!

Ha, ha, ha

Blushing

Humph

Wah!

tree characters

This grandfather tree is getting on in years.

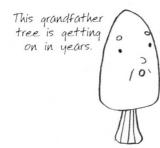

The branches and under-growth look like hands.

I'm living in harmony with other small creatures.

insect characters

Try making big eyes into glasses.

It's fine to leave out the "arms" in the middle, just as you please.

The patterns on the wings can create a sense of beauty.

The small prickles are short and cute and look like hands.

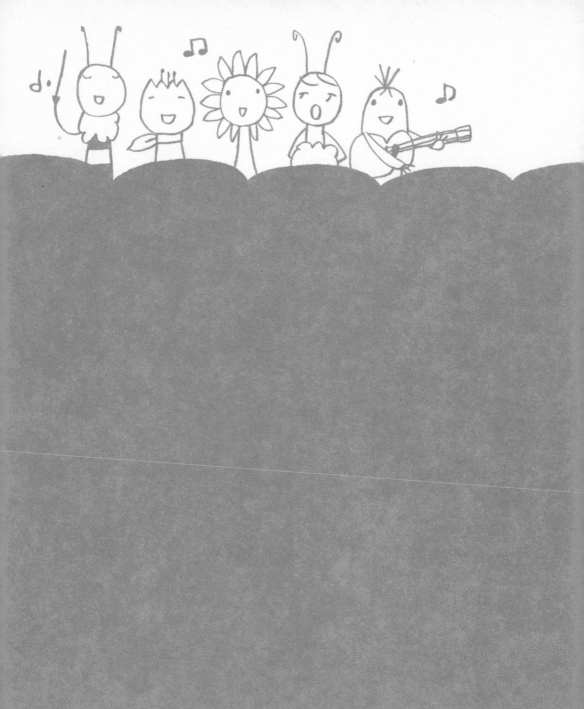

chapter 1
spring, summer, autumn, and winter in the forest

let's observe wonderful living things in the forest during all four seasons

cherry blossoms/ rape blossoms

plum trees/ butterbur flowerbuds

tulips/ daisies

pansies/ violets

anemones/ hyacinths

camellias/ peonies

roses/ lilacs

ants/ dandelions

carnations/ poppies

swallowtail butterflies/ primroses

lilies-of-the-valley/ lilies

chinese lantern plants/ praying mantis

hydrangeas/ swallows

water lilies/ ornamental carp

marguerite/ wild strawberries

lavender/ chamomile

sunflowers/ morning glory

rhinoceros beetles/ stag beetles

hibiscus/ palm trees

frogs/ fireflies

autumn maple trees/ salvia

maple trees/ cosmos

ginkgo trees/ pampas grass

akebi vines/ red spider lilies

konara oak trees/ acorns

chestnuts/ chestnuts in burrs

christmas trees/ poinsettias

cherry blossoms

The salt-pickled leaves that are used for cherry blossom rice cakes are from the oshima cherry trees.

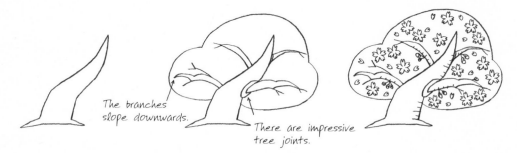

The branches slope downwards.

There are impressive tree joints.

1. Draw a trunk that has a strong undulating curve to it.

2. Draw curved arc–shaped branches and the whole outline of the blossoms on the tree.

3. Add the blossoms, buds, and sideways lines on the trunk.

rape blossoms

The leaves can be boiled and eaten, the seeds are used to make oil, and the strained lees to make fertilizer.

1. After drawing the flowers in the foreground, draw the flowers behind them, as well.

2. Draw a long, straight stem stretching upwards.

3. Finish it off by adding the flowers, seeds, and leaves arranged alternately from the top down.

let's draw!

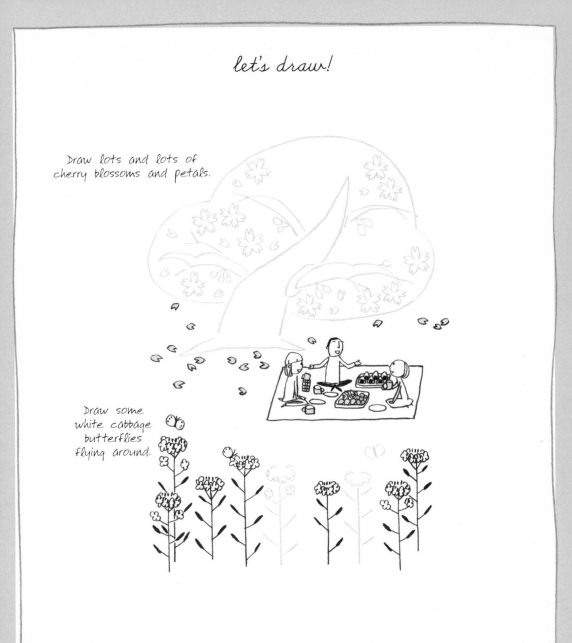

Draw lots and lots of cherry blossoms and petals.

Draw some white cabbage butterflies flying around.

plum trees

The term for the rainy season ("plum rain") originates from the fact that there is a lot of rain when the plum fruit ripens.

The twigs grow upwards towards the sky.

New branches are growing upwards from the sides of the pruned branches.

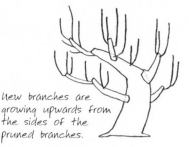

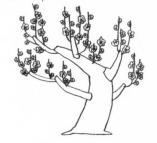

1. Draw a roughly curved trunk.

2. The branches are pruned, and the twigs coming from them are pointing upwards.

3. Finish off the picture by drawing the buds and flowers on the twigs.

butterbur flower buds

The leaves of these flowers can grow as long as 6 feet (2 meters) when they are planted in a place with a lot of water and good ventilation.

Give a slight curve to the tips of the leaves.

1. First of all draw the buds.

2. Wrap the calyx around the buds.

3. Draw some more overlapping leaves on the calyx.

let's draw!

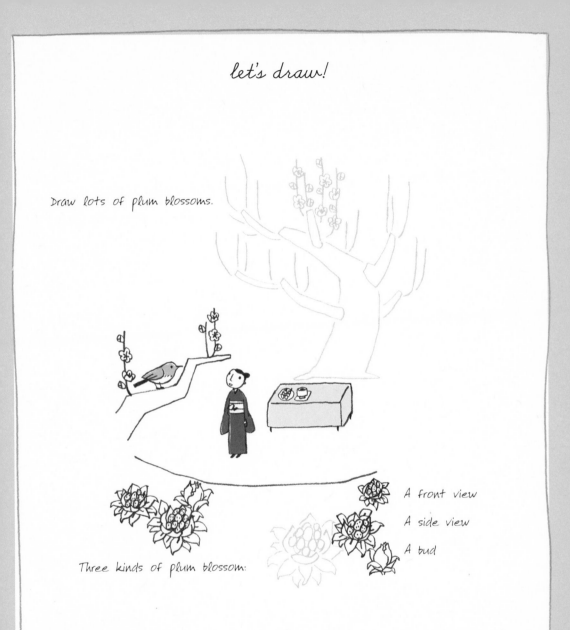

Draw lots of plum blossoms.

Three kinds of plum blossom:

A front view

A side view

A bud

tulips

They were introduced to the Netherlands from Turkey and became so popular that they made a great economic impact.

 ←

Draw the flower wider at the base.

 ←

1. Expand the flower by drawing the front, side, and back petals in that order.

2. Draw a long, straight stem stretching upwards.

3. Overlap the pointed leaves from the base of the flower.

daisies

Because daisies bloom for a long time they have several other names in Japanese that mean "long-lived."

Draw petals in between petals.

1. Decide on the center and then draw layers of overlapping petals.

Increase the thickness of the flower by drawing another layer of petals on the underside.

2. Draw a stem that is not very long.

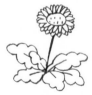

3. Finish the picture by drawing jagged-edged leaves overlapping on the ground.

let's draw!

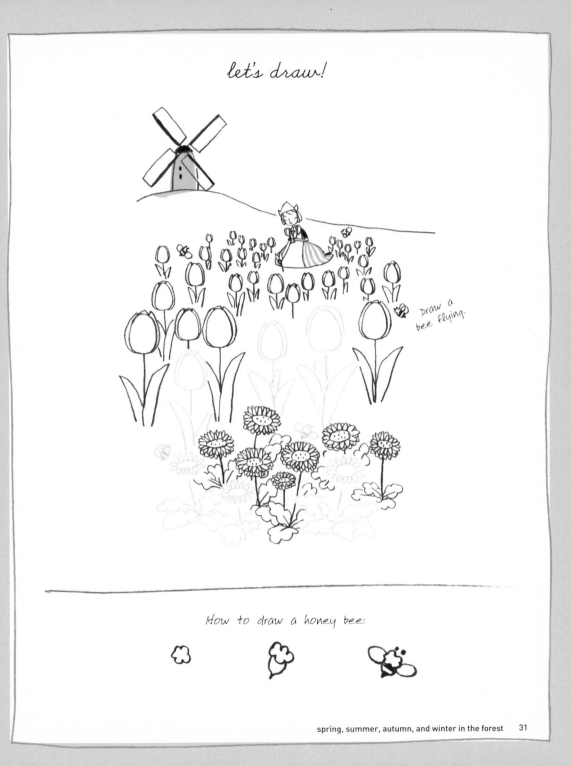

Draw a
bee flying.

How to draw a honey bee:

pansies

The name "pansy" comes from the word "pensé" in french which means thoughts. Don't you think that it looks like a person thinking?

 Draw a shape.

 Draw a petal to the left and a petal to the right.

Draw two petals in the back.

1. Draw the five petals in order starting from the petal at the front.

2. Draw the stem and a pair of leaves growing from the base.

3. Draw a few more overlapping leaves.

violets

Because a violet looks much like an inkspot ("sumiire" in Japanese) it came to be known as sumire.

 Draw two petals at the top.

 Draw three at the bottom.

1. Draw the five petals starting with the biggest one.

2. Draw the stem with the image of propping up the flowers from the back.

The flowers droop down from the back.

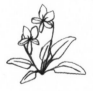

3. Draw the triangular leaves with rounded tips.

let's draw!

Draw some
swallowtail butterflies.

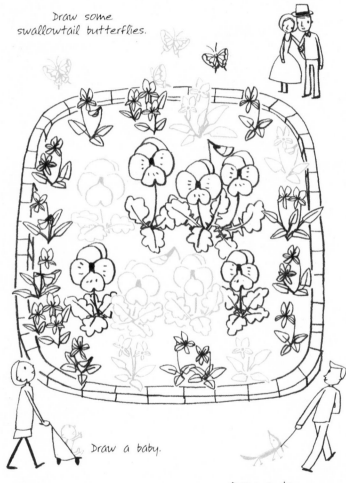

Draw a baby.

Draw a dog.

anemones

The anemone came from Mediterranean coastal areas. The part that looks like the petals of the flower is actually the calyx.

 Concentrate on the direction the flower is facing as you draw.

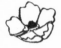 The flower is shaped like a bowl.

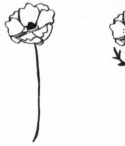

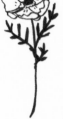

1. After drawing the center, draw the calyx as if it is wrapped around a bowl shape.

2. Draw a gently curved stem.

3. Draw the tiny separate leaves.

hyacinths

After the flower has bloomed, pick only the flower and keep the bulb for reuse the following year.

How to draw the flowers:

① Draw the three-pointed petals

② Draw wider petals between them.

Join the flowers together with gently curved lines.

1. Draw flowers closely gathered together.

2. Draw the stem and leaves with pointed tips.

3. Draw a pot containing water and roots growing from the bulb.

let's draw!

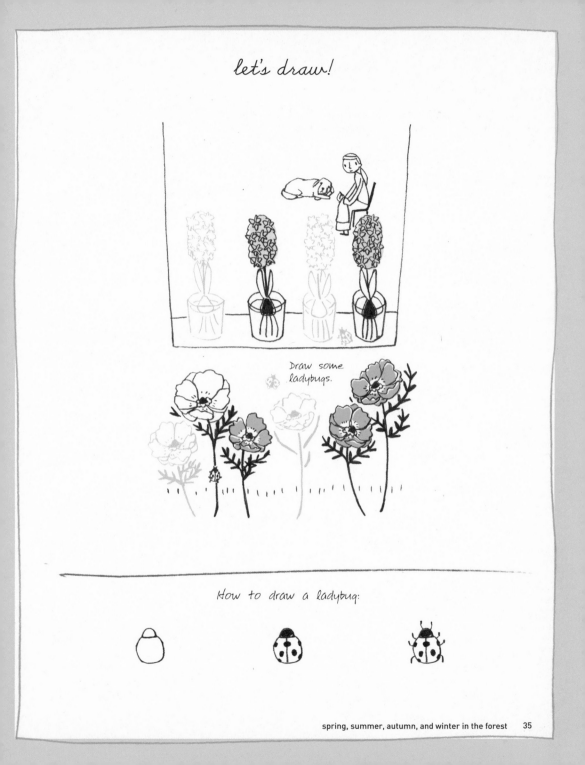

Draw some ladybugs.

How to draw a ladybug:

camellias

The camellia blossoms mark the arrival of spring. Camellia oil, which is extracted from the seeds, is renowned as a high quality oil.

Focus attention on this spot as the center of the whole flower.

The tips of the leaves are a little pointed.

1. Starting at the front, draw overlapping petals from the stamen and pistil.

2. Draw the petals at the back.

3. Draw the leaves.

peonies

Peonies are used to exemplify the appearance of feminine beauty as in the saying "standing, she is as lovely as a Chinese peony, sitting, as lovely as a tree peony."

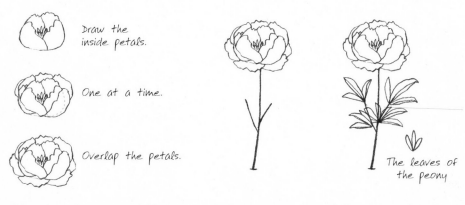

Draw the inside petals.

One at a time.

Overlap the petals.

The leaves of the peony

1. From the inside outwards draw the gently overlapping petals.

2. Draw a stem going straight up.

3. Draw the rather tiny leaves that are divided into three.

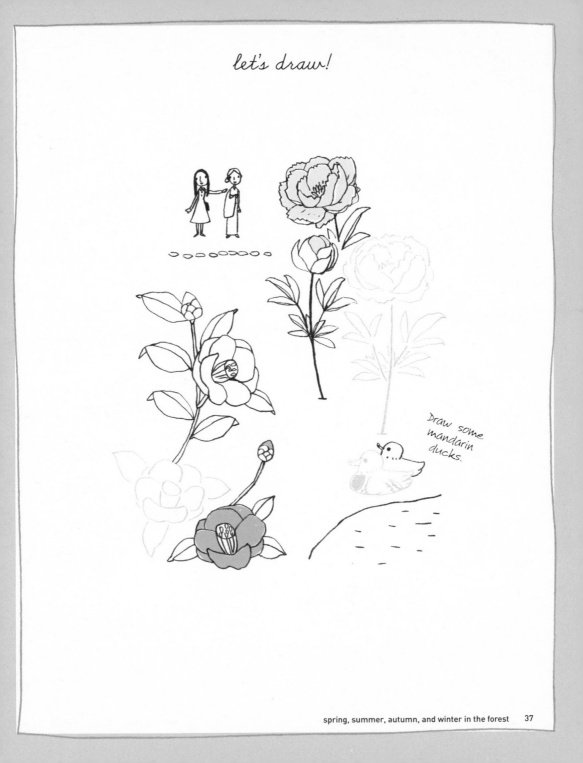

let's draw!

Draw some mandarin ducks.

Roses were introduced into Europe from
China and enchanted the aristocracy.

 Make divisions in a triangle.

 Draw the petals wrapped around each other in the shape of a shirt collar.

Add more outer petals in all three directions.

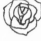 Add even more petals, each one slightly different.

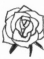 While looking at the whole flower, draw the petals at the back and the calyx.

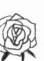

1. Draw the petals overlapping each other from the inside outwards.

2. Draw even more overlapping petals and the calyx.

3. Draw the stem, thorns, and leaves.

lilacs

Usually lilacs have four petals. It is said that finding
a flower with five petals brings happiness.

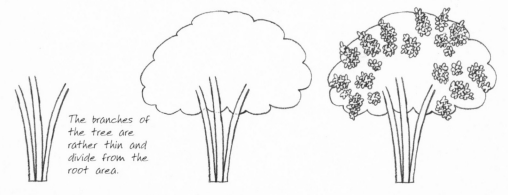

The branches of the tree are rather thin and divide from the root area.

1. Draw the branches.

2. Draw the outline of all of the tree's leaves.

3. Draw groups of flowers toward the outside edge of the tree.

let's draw!

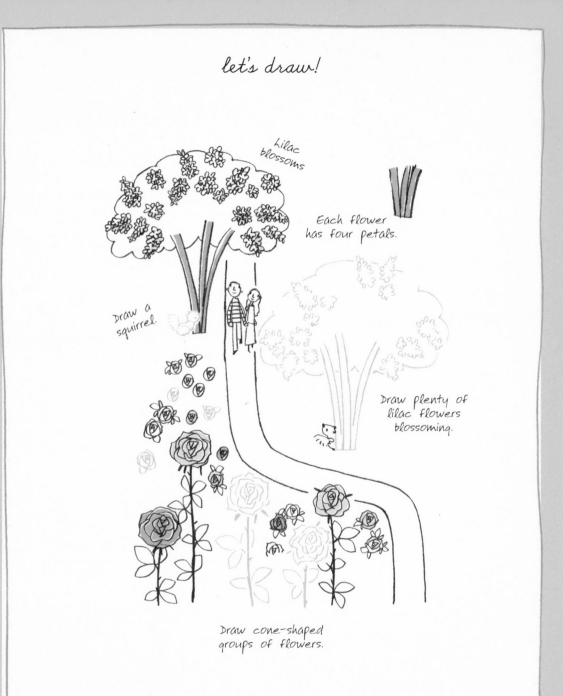

Lilac blossoms

Each flower has four petals.

Draw a squirrel.

Draw plenty of lilac flowers blossoming.

Draw cone-shaped groups of flowers.

ants

The ants that are busy working outside are the older generation of ants. The younger ants work inside the nest.

All of the legs grow from the abdominal part of the ant.

The tip of the ant's nose is a little pointed.

1. Draw the head and antennae.

2. Draw the stomach and the tapered bottom.

3. Draw the back legs.

dandelions

The english name "dandelion" originates from a description of the leaves, which resemble a lion's teeth.

Draw the first layer of petals.

Draw the second layer of petals partly revealed between these petals.

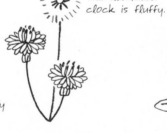

The dandelion clock is fluffy.

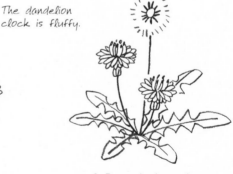

1. Draw the flower and the husk (calyx) that holds it.

2. Various stems come from one root.

3. Draw the jagged-edge leaves.

let's draw!

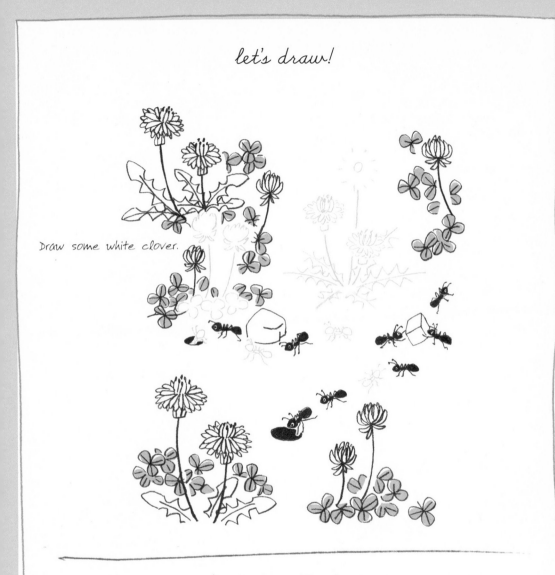

Draw some white clover.

How to draw white clover:

 Petals pointing up-
wards are gathered
in a group.

 This part is a
little withered.

carnations

In Ancient Greece, crowns of carnations were offered to the Gods.

 Draw the group of petals that form the center of the flower.

 Then draw three petals wrapped around that.

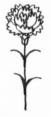

1. Starting from the center, build up the number of petals.

2. Draw even more petals and the husk that holds them.

3. Draw a completely straight stem and the leaves.

poppies

Also known as "hinageshi" in Japanese, the seeds of the poppy are sprinkled on top of red bean-paste buns.

 The petals form the shape of a bowl.

 Tiny pleats are added to the petals.

 The stem is long and straight.

1. Draw a rough bowl shape

2. Draw the petals. (A poppy does not have a husk.)

3. Draw a long, straight stem and branches of tiny leaves.

let's draw!

How to draw a bunch of carnations:

Arrange the flowers together into a round shape.

The leaves give an accent to the arrangement.

swallowtail butterflies

Have you ever caught sight of these butterflies drinking water in the summer? That's how they control their body temperature.

The direction that the arc-shaped pattern faces is different on the upper and lower wings.

1. Draw the wings and body, eyes, and antennae.

2. Draw the biggest pattern on the wings.

3. Draw an intricate pattern on the wings.

primroses

In German, the primrose is known as the "key flower" as it represents the key to open the door to spring.

Front view:
There is a small cut on the edge of the petal.

Sideways:
The flowers form an arc shape.

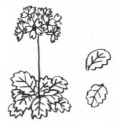

1. Draw the flowers blossoming in a group.

2. Draw a long, straight stem.

3. Draw overlapping leaves covering the base of the plant.

let's draw!

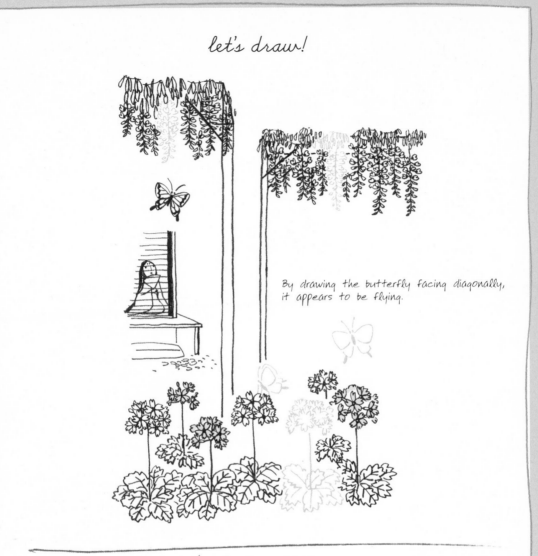

By drawing the butterfly facing diagonally, it appears to be flying.

How to draw wisteria:

The leaves are in pairs, opposite each other, on the left and right. (In an illustration, the leaves in back are omitted.)

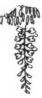

Draw the flowers hanging downwards. The flowers open from the top downwards

lilies-of-the-valley

In France there is the custom to give lilies-of-the-valley to people to express gratitude.

The edges of the leaves are wavy.

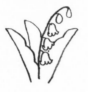

The flowers open from the lower ones up.

1. Draw the bell-shaped flowers and the stem that bends down with the weight.

2. Draw the outline of the leaves.

3. Draw the parts of the leaves facing the front and the veins in the leaves.

lilies

The beautiful curve-backed shape of the lily is used in many flags and emblems.

Draw a slightly wide petal that has a split tip.

Draw thin petals with their tips curling back.

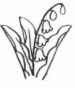

There are a number of flowers on one stem.

1. Draw three well-balanced petals.

2. Draw three more petals between them, and the funnel-shaped axil.

3. Draw a fairly long stem and leaves that shoot out in all directions.

let's draw!

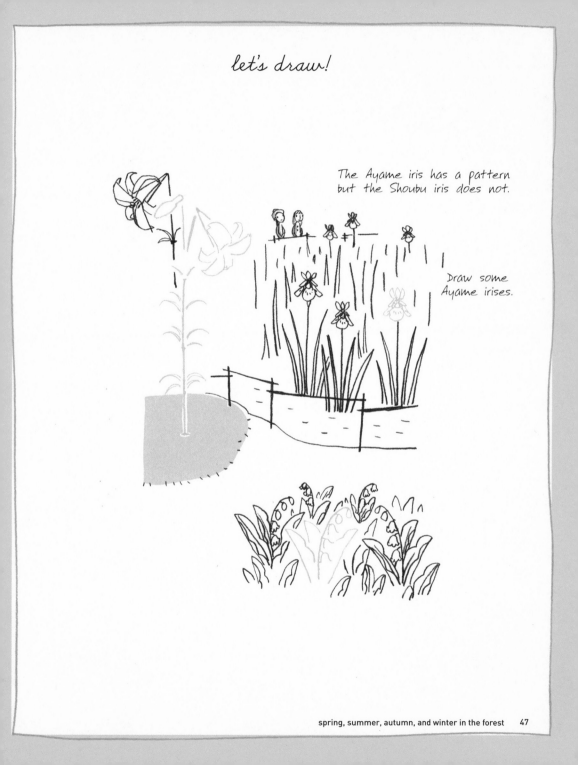

The Ayame iris has a pattern but the Shoubu iris does not.

Draw some Ayame irises.

chinese lantern plant

The name for this plant in Japanese means inflating cheeks and comes from the image of someone playfully blowing into the fruit to make a sound.

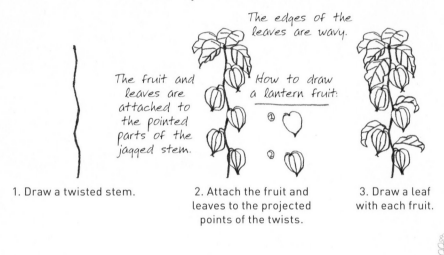

The edges of the leaves are wavy.

The fruit and leaves are attached to the pointed parts of the jagged stem.

How to draw a lantern fruit:

1. Draw a twisted stem.

2. Attach the fruit and leaves to the projected points of the twists.

3. Draw a leaf with each fruit.

praying mantis

After eating it is said to scrupulously clean its important forelegs.

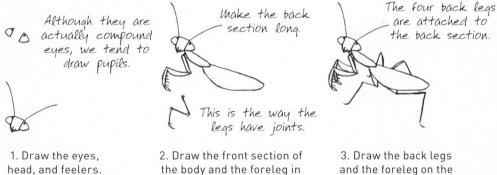

Although they are actually compound eyes, we tend to draw pupils.

Make the back section long.

The four back legs are attached to the back section.

This is the way the legs have joints.

1. Draw the eyes, head, and feelers.

2. Draw the front section of the body and the foreleg in the foreground.

3. Draw the back legs and the foreleg on the other side.

let's draw!

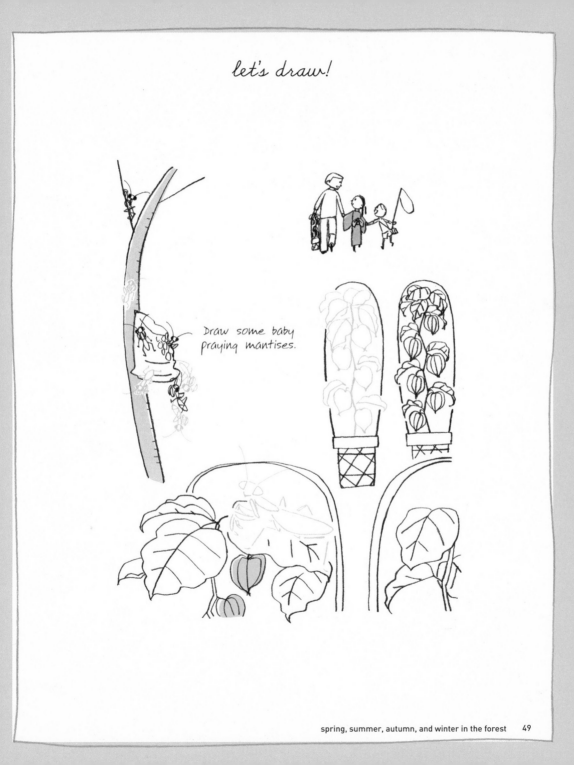

Draw some baby praying mantises.

hydrangeas

A beautiful feature of hydrangeas is that a few days after they bloom the color of the flowers gradually changes!

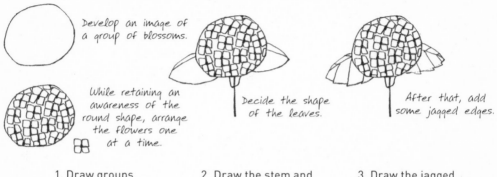

Develop an image of a group of blossoms.

While retaining an awareness of the round shape, arrange the flowers one at a time.

Decide the shape of the leaves.

After that, add some jagged edges.

1. Draw groups of blossoms in round shapes.

2. Draw the stem and leaves springing from the right and left.

3. Draw the jagged edges and veins of the leaves.

swallows

Did you know that they can fly at speeds up to 322 mph (200 kph)?

There is a red circle around the eyes.

The tail and wings are sharply pointed.

1. Draw the eyes, an outline, the beak, and a decorative feather.

2. Draw the body and tail.

3. Draw the pattern on the body and the wings.

let's draw!

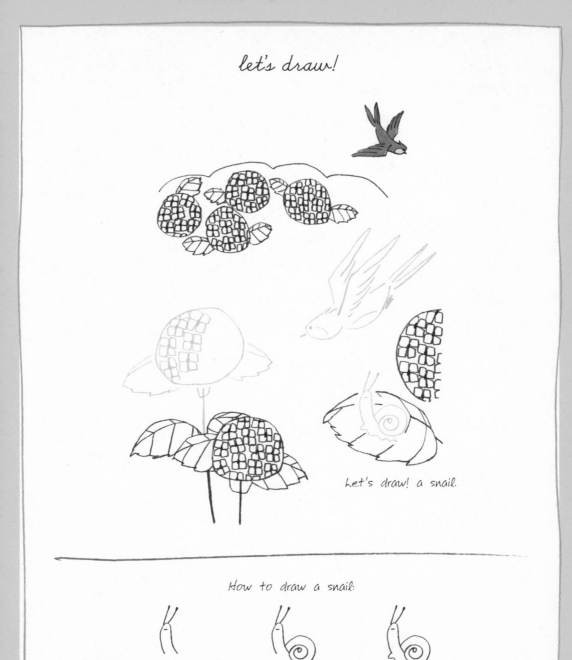

Let's draw! a snail.

How to draw a snail:

The eyes are on the
end of the feelers.

The feet are wavy.

water-lilies

Because the flower opens during the day and closes at night, it is called the sleeping lotus.

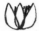

Draw the petals in the front.

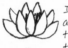

In between these add the petals in the back peeping through.

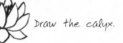

Draw the calyx.

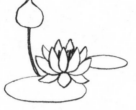

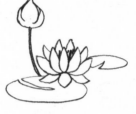

1. Draw the petals in order from the center outwards.

2. Draw the leaves floating on the water and a flower bud.

3. Add the split in the leaves and the lines showing the unopened petals.

ornamental carp

According to legend, the carp that ascends the waterfall actually becomes the waterfall, and this is how it became a symbol of success.

The top lip and whiskers are its special features.

The stomach is flat and the back is a little rounded.

1. Draw the head, gills, whiskers, and body.

2. Draw the fins.

3. Add a pretty pattern.

let's draw!

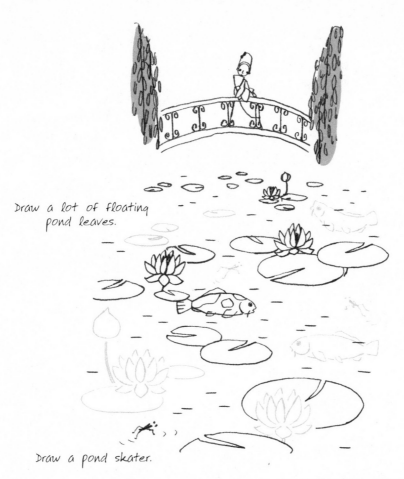

Draw a lot of floating pond leaves.

Draw a pond skater.

How to draw a pond skater:

Draw an X sign.

Ripples in the water signify that it is a pond skater.

marguerite

The origin of this daisy's name comes from the greek word "margarite," which means pearl.

 Draw the top, bottom, left, and right petals.

 Draw the petals in between them.

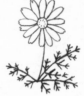 The leaves are intricate and separate at the base.

1. Draw the petals that open into a radial shape.

2. Draw a long stem and stalks for the leaves.

3. Draw the intricate leaves that branch off.

wild strawberries

In Europe, this plant is said to bring good luck and even miracles.

Draw the tiny lumps in the middle.

Add more around the edges.

The leaves face in three directions.

There are five petals.

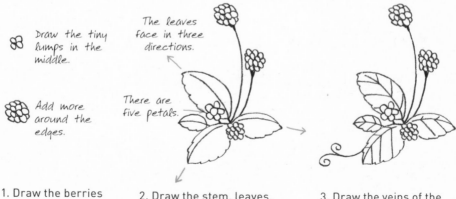

1. Draw the berries from the center outwards.

2. Draw the stem, leaves, other fruit, and flowers.

3. Draw the veins of the leaves and a curly stalk.

let's draw!

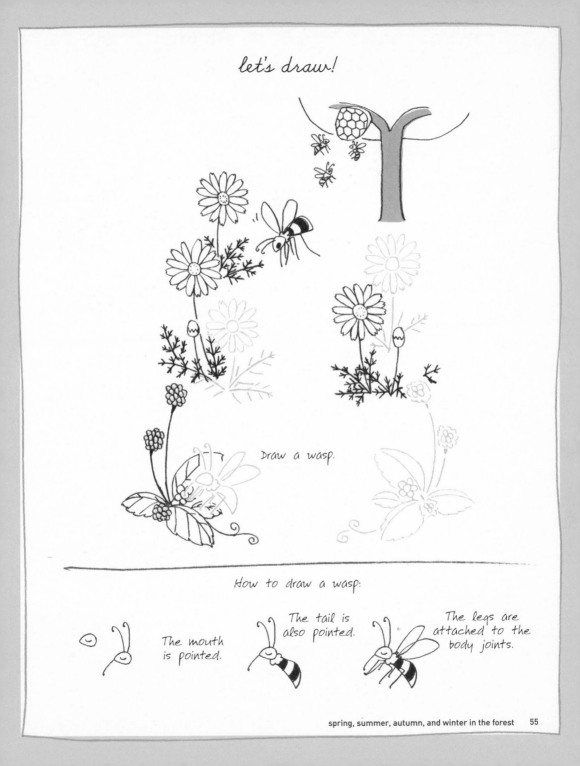

Draw a wasp.

How to draw a wasp:

The mouth is pointed.

The tail is also pointed.

The legs are attached to the body joints.

lavender

The fragrance of the lavender is effective for relieving headaches, repelling insects, and as an aid to relaxation.

Blossoming flowers are
dotted here and there.

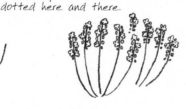 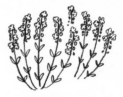

1. Draw the stalks growing in a radial shape.

2. Draw the buds and flowers on the ends of the stalks.

3. Draw leaves facing each other on the left and right.

chamomile

Also known as "doctor chamomile" due to its ability to prevent disease in plants planted nearby.

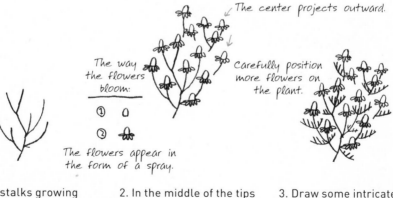

The center projects outward.

The way the flowers bloom:

① ◯

② 🌼

Carefully position more flowers on the plant.

The flowers appear in the form of a spray.

1. Draw stalks growing upwards and branching out from the center.

2. In the middle of the tips of the stalks draw some rounded flowers.

3. Draw some intricately branching leaves.

let's draw!

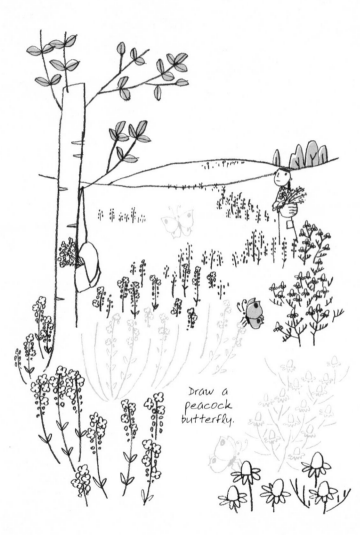

Draw a peacock butterfly.

sunflower

When the bud on the stem is soft it moves a lot, following the sun.

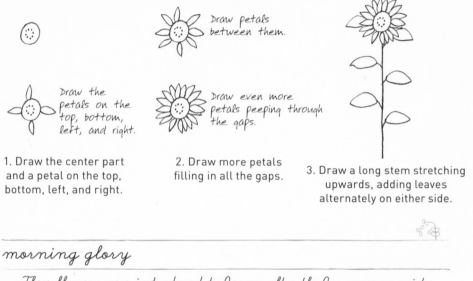

Draw the petals on the top, bottom, left, and right.

Draw petals between them.

Draw even more petals peeping through the gaps.

1. Draw the center part and a petal on the top, bottom, left, and right.

2. Draw more petals filling in all the gaps.

3. Draw a long stem stretching upwards, adding leaves alternately on either side.

morning glory

These flowers were introduced to Japan after the Japanese envoi to the Tang dynasty brought the seeds home for medicinal purposes.

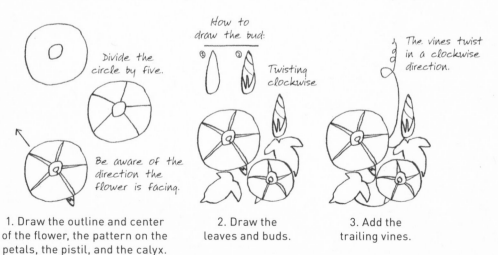

Divide the circle by five.

Be aware of the direction the flower is facing.

How to draw the bud:

Twisting clockwise

The vines twist in a clockwise direction.

1. Draw the outline and center of the flower, the pattern on the petals, the pistil, and the calyx.

2. Draw the leaves and buds.

3. Add the trailing vines.

let's draw!

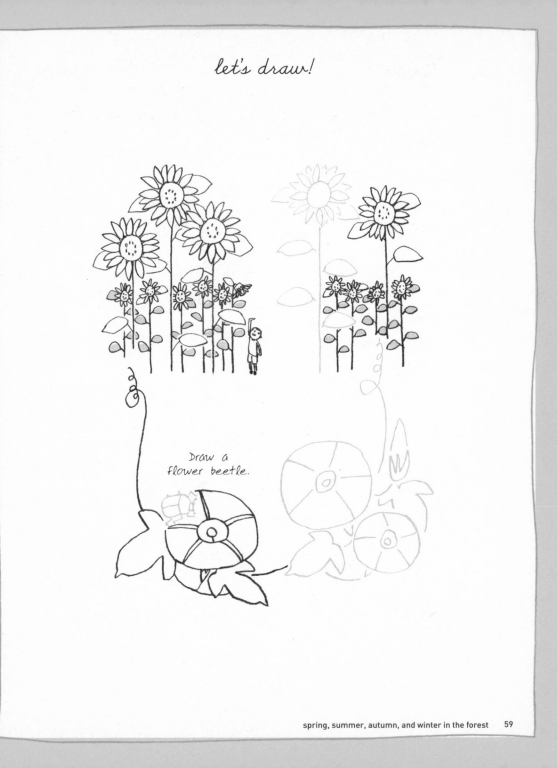

Draw a
flower beetle.

rhinoceros beetle

By applying the principle of the lever, the rhinoceros beetle uses its horns to throw its opponent up into the air.

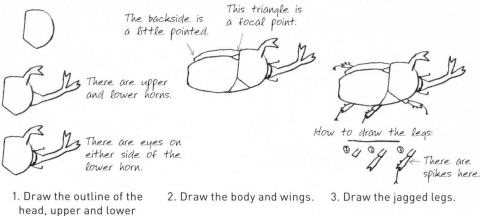

The backside is a little pointed.

This triangle is a focal point.

There are upper and lower horns.

There are eyes on either side of the lower horn.

How to draw the legs:

There are spikes here.

1. Draw the outline of the head, upper and lower horns, eyes, and feelers.

2. Draw the body and wings.

3. Draw the jagged legs.

stag beetle

The horn, known as the large mandible (jaw), is used for fighting, and the small mandible, inside with hair on it, is used for eating.

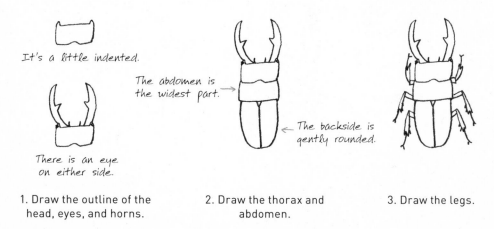

It's a little indented.

The abdomen is the widest part.

There is an eye on either side.

The backside is gently rounded.

1. Draw the outline of the head, eyes, and horns.

2. Draw the thorax and abdomen.

3. Draw the legs.

let's draw!

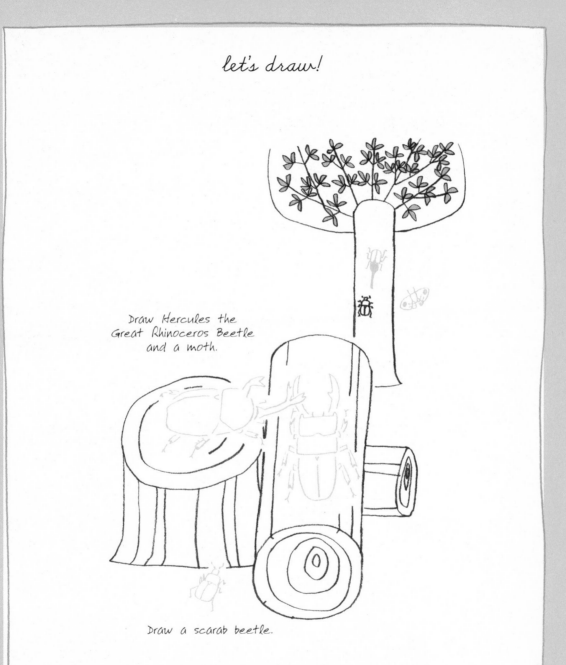

Draw Hercules the
Great Rhinoceros Beetle
and a moth.

Draw a scarab beetle.

hibiscus

This is not an herbaceous plant; it belongs to the tree family.
Flowers bloom at the end of the newly grown branches.

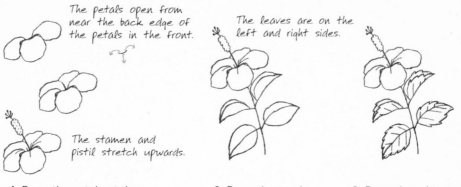

The petals open from near the back edge of the petals in the front.

The stamen and pistil stretch upwards.

The leaves are on the left and right sides.

1. Draw the petals at the front, then those at the back, and the stamen and pistil.

2. Draw the trunk and the outline of the leaves.

3. Draw the veins and the jagged edges of the leaves.

palm trees

The fruit of the palm tree, the coconut, contains 1 quart (1 liter)
of water and delicious flesh.

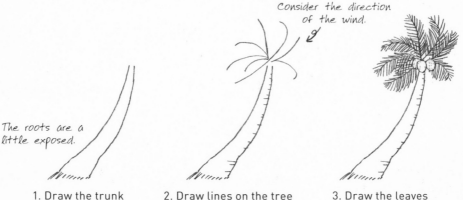

Consider the direction of the wind.

The roots are a little exposed.

1. Draw the trunk of the tree.

2. Draw lines on the tree and the stalks that are in the middle of the leaves.

3. Draw the leaves and the coconuts.

let's draw!

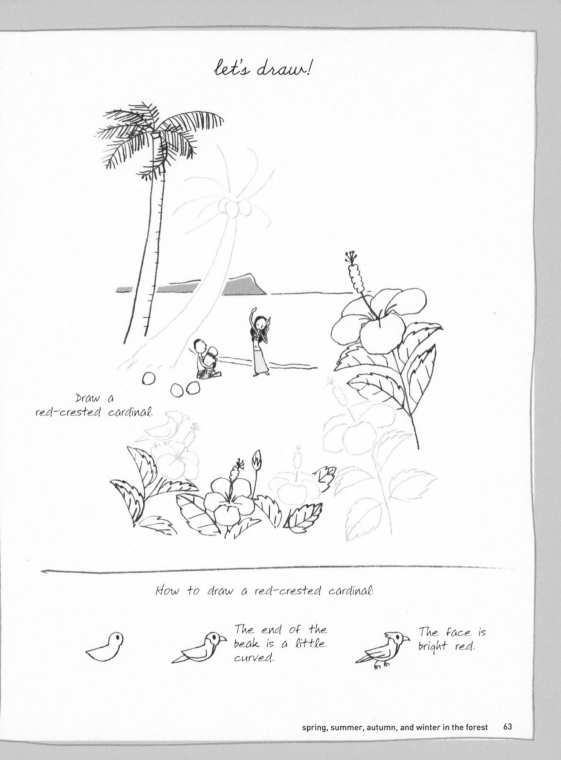

Draw a
red-crested cardinal.

How to draw a red-crested cardinal:

The end of the
beak is a little
curved.

The face is
bright red.

frogs

Frogs can stick firmly anywhere because they have sucker pads on the ends of their hands and feet.

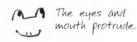

The eyes and mouth protrude.

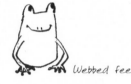

Draw the bow-shaped arms and legs.

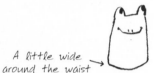

A little wide around the waist

Webbed feet

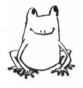

1. Draw the eyes, mouth, and body.

2. Draw the hands.

3. Add the back legs.

fireflies

They glow without producing heat more effective than electricity.

Note the difference between the heike firefly and genji firefly.

1. Draw the head and wings.

2. Color the wings black and draw the feelers and the pattern on the body.

3. Draw the legs and the light glowing from the backside.

let's draw!

Draw some
bulrushes.

The backside
is a little
pointed.

autumn maple trees

*When the temperature goes down and the air becomes dry,
the leaves turn red as the sunlight touches them.*

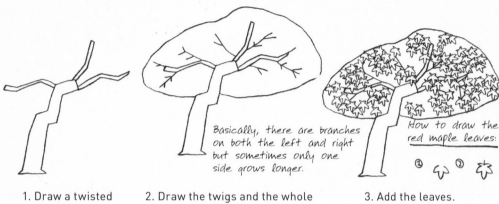

Basically, there are branches
on both the left and right
but sometimes only one
side grows longer.

How to draw the
red maple leaves:

① ②

1. Draw a twisted
trunk and branches.

2. Draw the twigs and the whole
outline of the leaves on the tree.

3. Add the leaves.

salvia

*The flower developed a form that helped the pollen to proliferate
and made it easy for hummingbirds and bees to suck the nectar.*

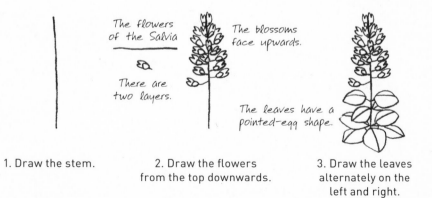

The flowers
of the Salvia

There are
two layers.

The blossoms
face upwards.

The leaves have a
pointed-egg shape.

1. Draw the stem.

2. Draw the flowers
from the top downwards.

3. Draw the leaves
alternately on the
left and right.

let's draw!

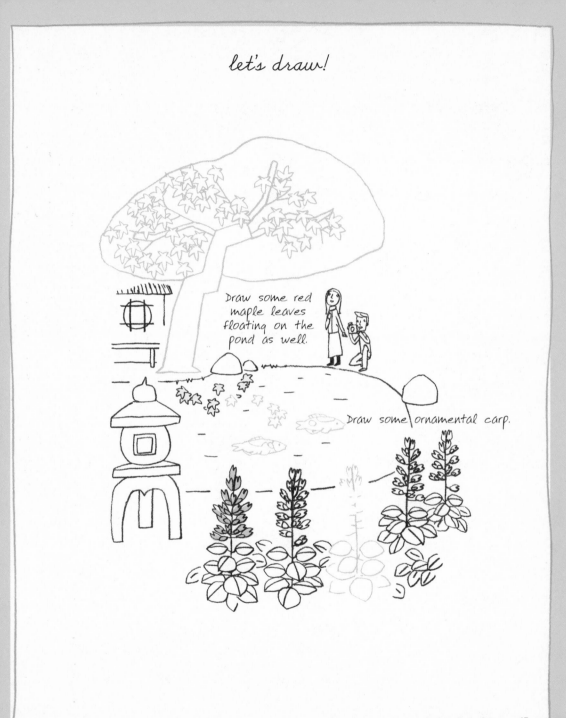

Draw some red maple leaves floating on the pond as well.

Draw some ornamental carp.

maple trees

The original name for this tree in Japanese means "frogs' feet" and was inspired by the shape of the leaves, which resemble frogs' feet.

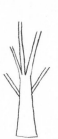

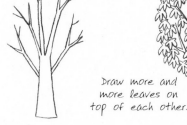

Draw more and more leaves on top of each other.

1. Draw the trunk

2. Draw the branches and overall outline.

3. Draw the leaves.

cosmos

The word "cosmos" in Greek means "orderliness" and when you see the neat and orderly way the flowers bloom you can understand the origin.

Draw guidelines in between as well.

Use a cross shape as the guideline.

The guidelines alone determine the position of the petals.

The tips are serrated.

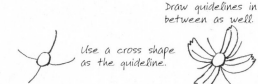

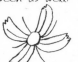

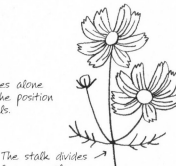

The stalk divides from one place.

1. Determine the center and draw the petals on the top, bottom, left, and right.

2. Add even more petals in between.

3. Draw the stalk, leaves, buds, and one more flower and it is finished!

let's draw!

How to draw the
leaves of the maple tree

①
②

gingko trees

The fruit of the gingko tree (gingko nuts) are effective to help stop coughs, and the wood from the tree is used to make high quality wooden chopping boards and foundations.

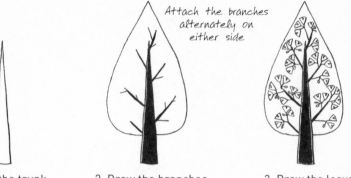

Attach the branches
alternately on
either side

1. Draw the trunk.

2. Draw the branches and the overall outline of the tree's leaves.

3. Draw the leaves and it is finished!

pampas grass

Used as material to make thatched roofs, watch out for the serrated edges of the leaves!

Draw the fluffy parts.

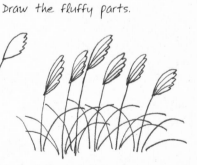

1. Decide the direction of the wind before drawing the stalks.

2. Draw the outline of the plumes fluttering in the wind.

3. Draw defining lines in each plume one by one and the leaves.

let's draw!

Draw a red dragonfly.

How to draw
the leaves of the
qingko tree:

① ⌣

② ▽▽

③ ▽▽

Growing from
one point only

How to draw a red dragonfly:

There is a pattern on
the tips of the wings.

akebi vines

When the fruit from this tree ripens and breaks open the shape looks like a yawn. The name of this plant originates from the word "akubi" in Japanese which means "yawn" in English.

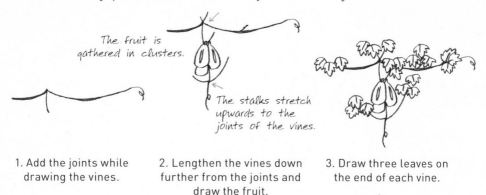

The fruit is gathered in clusters.

The stalks stretch upwards to the joints of the vines.

1. Add the joints while drawing the vines.

2. Lengthen the vines down further from the joints and draw the fruit.

3. Draw three leaves on the end of each vine.

red spider lilies

Because this flower is poisonous it can often be found planted on the ridges between rice fields to keep away mice and moles.

 Use six petals as your guideline.

Build up thickness.

It grows facing upwards.

1. Draw the flowers from the front to the back in order.

2. Draw the flowers peeping out from the back and the long and totally straight stem.

3. Draw the stamen and pistil.

let's draw!

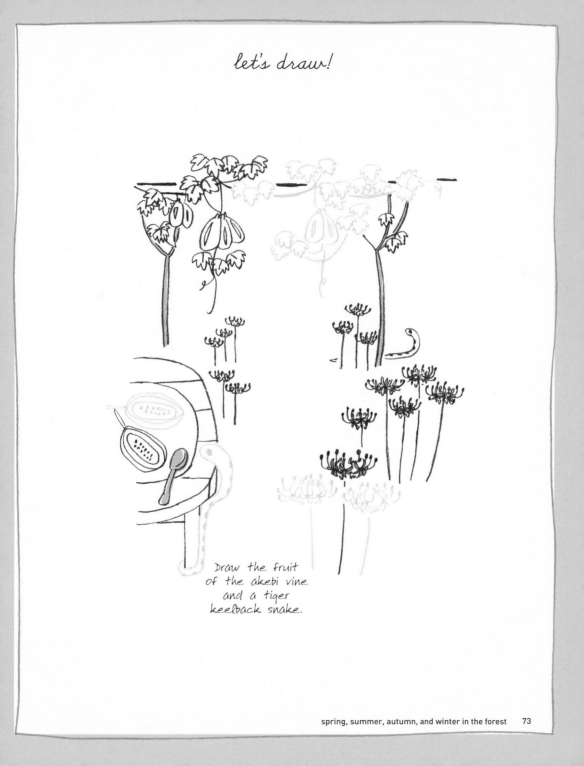

Draw the fruit
of the akebi vine
and a tiger
keelback snake.

konara oak trees

You can pick lots of acorns from these trees. The lumber is used for charcoal and for growing black chinese mushrooms (shiitake).

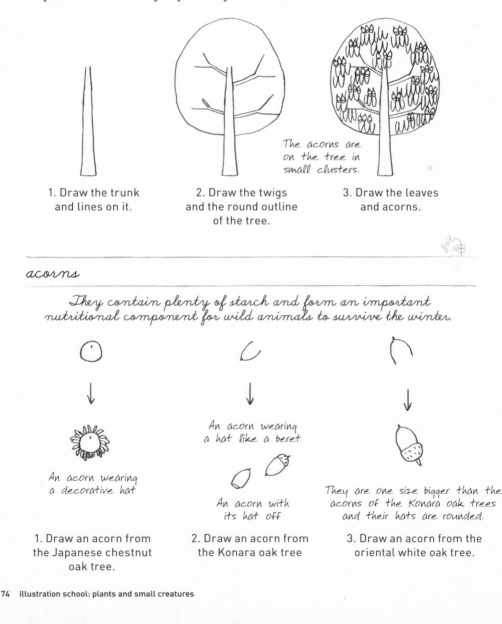

The acorns are on the tree in small clusters.

1. Draw the trunk and lines on it.

2. Draw the twigs and the round outline of the tree.

3. Draw the leaves and acorns.

acorns

They contain plenty of starch and form an important nutritional component for wild animals to survive the winter.

An acorn wearing a decorative hat

An acorn wearing a hat like a beret

An acorn with its hat off

They are one size bigger than the acorns of the Konara oak trees and their hats are rounded.

1. Draw an acorn from the Japanese chestnut oak tree.

2. Draw an acorn from the Konara oak tree

3. Draw an acorn from the oriental white oak tree.

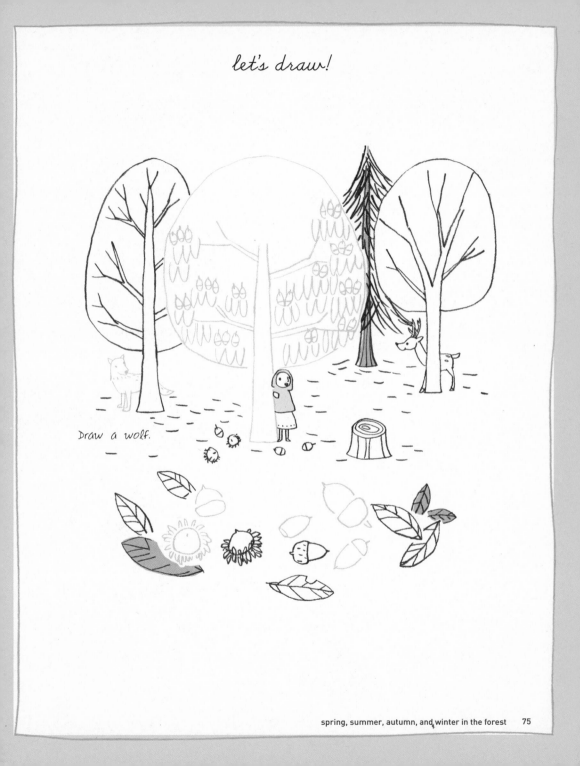

let's draw!

Draw a wolf.

chestnut trees

Because the wood from this type of tree is extremely hard, it is used for beams and railroad ties.

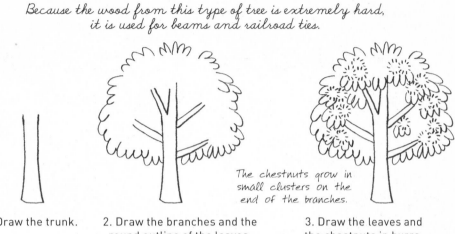

The chestnuts grow in small clusters on the end of the branches.

1. Draw the trunk.

2. Draw the branches and the round outline of the leaves.

3. Draw the leaves and the chestnuts in burrs.

chestnuts in burrs

The tannin derived from the burrs is suitable for natural dyeing.

Place one chestnut in the middle and one on either side to make three chestnuts snuggling up to each other.

Give a scattered look to the ends of the burrs.

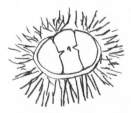

1. Draw the outline of the nuts snuggled up tightly together.

2. Draw the tip and roundness of the fruit and the rim of the burr.

3. Draw the burrs pointing in all directions in a disorderly way.

let's draw!

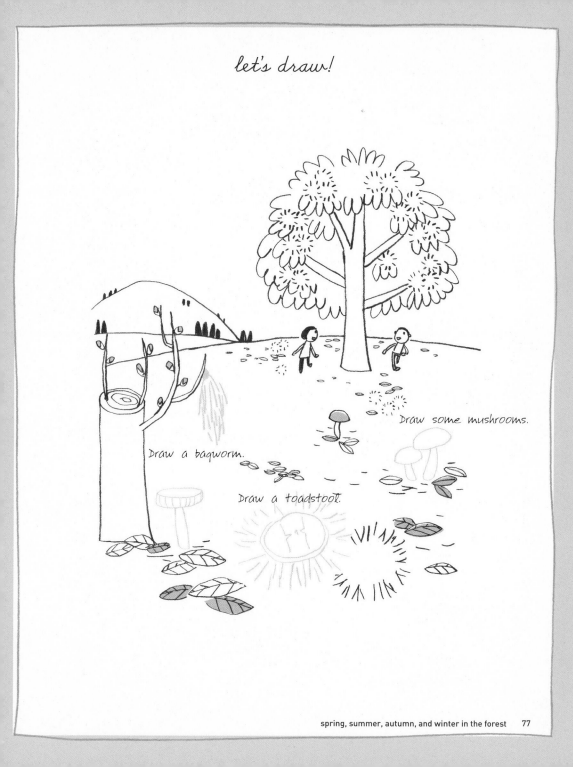

Draw some mushrooms.

Draw a bagworm.

Draw a toadstool.

christmas trees

Even in winter the leaves do not wither and so it can be used as a symbol of eternal life.

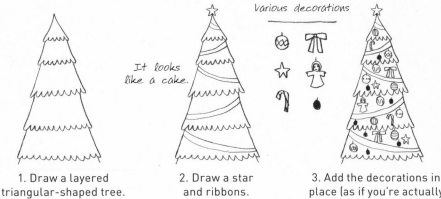

Various decorations

It looks like a cake.

1. Draw a layered triangular-shaped tree.

2. Draw a star and ribbons.

3. Add the decorations in place (as if you're actually decorating the tree).

poinsettias

With its red and green leaves and yellow flowers that look like bells, this plant is just right for Christmas!

These parts are actually flowers.

It is easier to draw the leaves if you draw them in a set of three at a time.

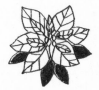

1. Draw the flower and the leaves that are right in the middle.

2. Draw the red part of the flowers.

3. Draw the green leaves peeping through the gaps between the red leaves.

let's draw!

Draw some reindeer.

Draw the decorations in your house.

Draw a church.

flower arrangement

You can create various arrangements of plants and flowers according to seasonal events. Try to experience the real feeling of handling the flowers and make some beautiful bouquets!

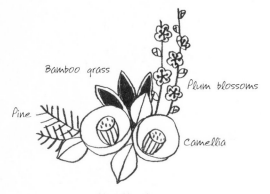

New Year's

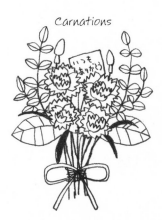

The Doll's Festival

First day of school

Mother's Day

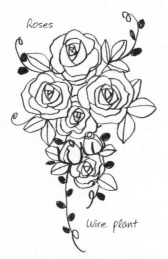

Roses

Wire plant

Wedding bouquet

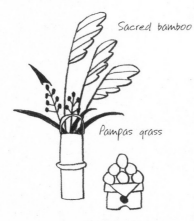

Sacred bamboo

Pampas grass

Moon viewing

A spider plant

Lavender

Ivy

A variety of plants in one pot

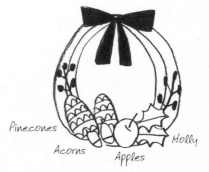

Pinecones

Acorns

Apples

Holly

Christmas

chapter 2 a harvest festival of fruit and vegetables

while enjoying the delicious taste of the fruits and vegetables, let's feel grateful to the people who grew them, and the blessings of nature

apples / bananas

strawberries / lemons

cherries / grapes

a pineapple / a watermelon

carrots / pumpkins

tomatoes / cabbages

corn / asparagus

melon / pears

apples

A delicious apple is red from top to bottom and has a pleasant fragrance.

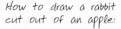

How to draw a rabbit cut out of an apple:

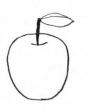

1. Draw the round outline of an apple.

2. Draw the indented part on the top and the calyx.

Draw a rabbit shape made from apple.

bananas

Just like red wine and green tea, bananas contain plenty of polyphenol.

The area around the edges of the tips of the bananas tends to bruise easily.

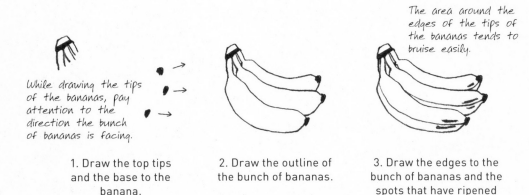

While drawing the tips of the bananas, pay attention to the direction the bunch of bananas is facing.

1. Draw the top tips and the base to the banana.

2. Draw the outline of the bunch of bananas.

3. Draw the edges to the bunch of bananas and the spots that have ripened and turned black.

let's draw!

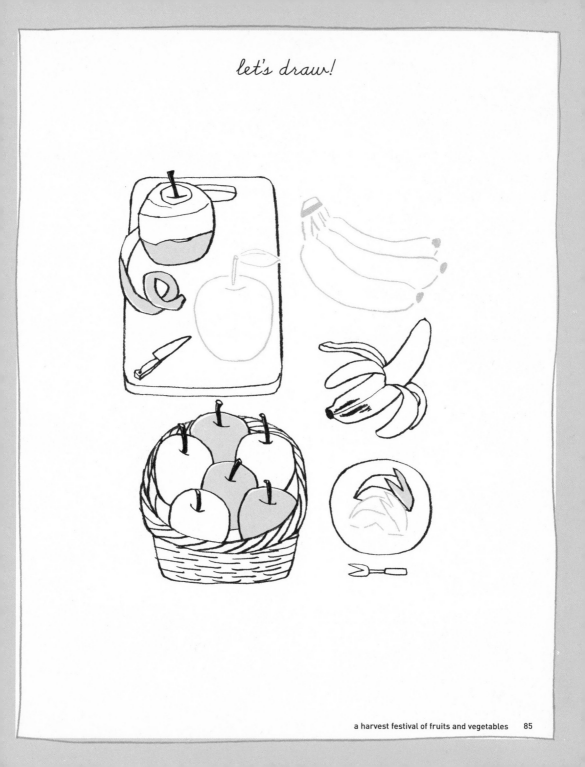

strawberries

Quickly washing the fruit just before eating it is the key to retaining the Vitamin-c and the delicious taste.

Draw the calyx just like a hat.

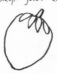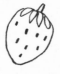

1. Draw the outline of the strawberry.

2. Draw the calyx.

3. Draw the little seeds on the surface.

lemon

The sour citric acid contained in lemons helps to ease fatigue and increase concentration. That makes them just right for sports!

The part that was attached to the tree has a wavy edge.

The opposite end protrudes.

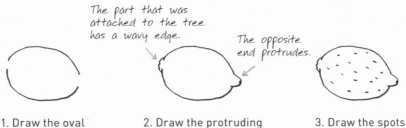

1. Draw the oval shape of the lemon.

2. Draw the protruding parts on both ends.

3. Draw the spots on the surface.

let's draw!

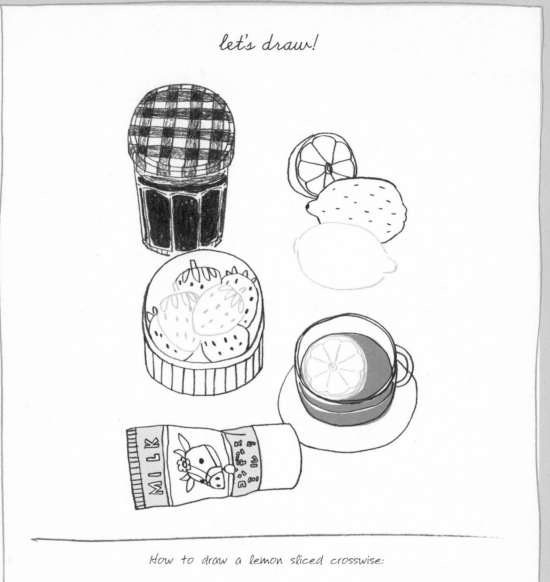

How to draw a lemon sliced crosswise:

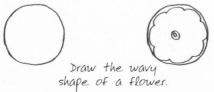

Draw the wavy
shape of a flower.

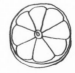

cherries

When you freeze cherries it is easy to make them into frozen sherbet. Try it.

Decide the position of the tops of the stalks.

The stalks are more curved than you would imagine.

The top of the fruit is indented.

1. Draw the outlines of the cherries.

2. Draw the indents on the fruit and the tips of the stalks.

3. Draw the curved stalk.

grapes

The grapes at the top of the bunch are sweet, so if you start eating them from the bottom you can enjoy delicious grapes until the end of the batch.

Draw the grapes that can be seen in the front.

Draw all of the grapes hidden behind them which are only partially visible.

The stalk has joints that make it gnarled.

1. Draw the grapes in the central area.

2. Draw more grapes so that the tip of the bunch appears narrow.

3. Draw the gnarled stalk.

let's draw!

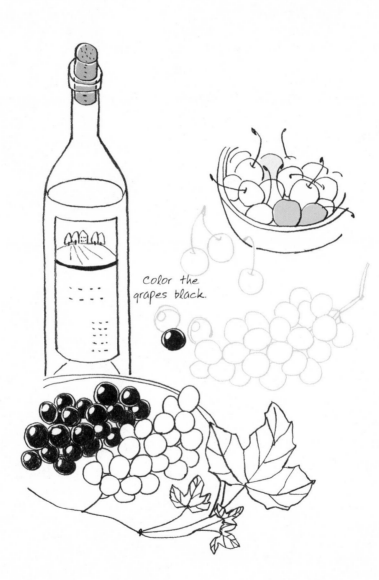

Color the grapes black.

a pineapple

Asian fried rice ("chahan") contains pineapple and is delicious!

The end of the pineapple is a little tapered.

Draw curved shapes alternately.

Draw the pineapple from the base.

1. Draw the outline of the fruit and the pattern on the surface that resembles a pine-cone.

2. Draw the guidelines of the leaves.

3. Add thickness to the leaves and draw the pointed pattern.

a watermelon

The seeds are arranged in the striped sections. Avoid these parts when slicing the watermelon.

Use the guidelines as a base and draw stripes.

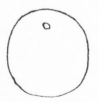
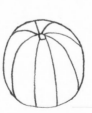
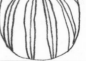
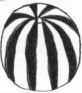

1. Draw the overall outline and the calyx.

2. Draw the guidelines for the stripes in a radial shape.

3. Draw some rough stripes.

4. Color the stripes black.

let's draw!

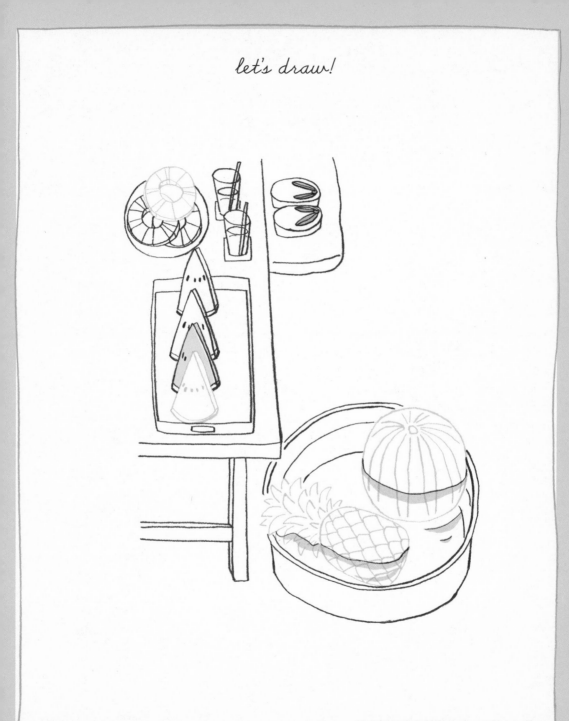

carrots

*The word "carrot" originates from the word "carotene,"
which helps to ease eye fatigue and stave off aging.*

It is sprouting
in a wild way.

The grooves are
all arranged in one line.

1. Draw the outline of
the vegetable and the base
to which the stalks and
leaves are attached.

2. Draw the stalks
and leaves.

3. Draw the grooved
lines on the carrot
and a wavy line around
the leaves.

pumpkin

*A long time ago, people used to preserve the pumpkins they dug up in
summer and then eat them in the winter to get their nutrition.*

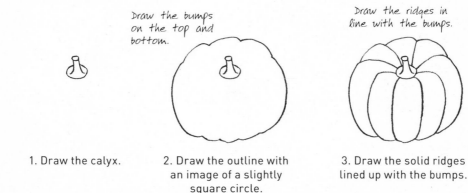

Draw the bumps
on the top and
bottom.

Draw the ridges in
line with the bumps.

1. Draw the calyx.

2. Draw the outline with
an image of a slightly
square circle.

3. Draw the solid ridges
lined up with the bumps.

let's draw!

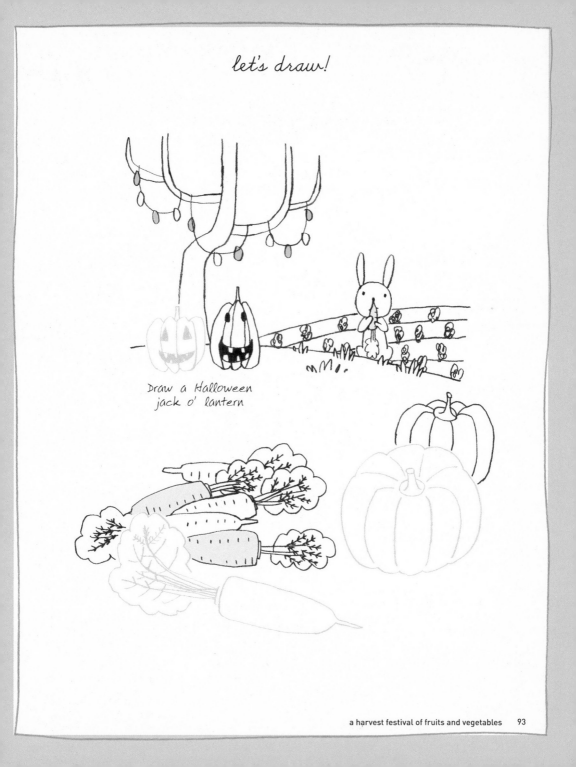

Draw a Halloween jack o' lantern

tomatoes

They taste good with salt, but sprinkled with sugar they are delicious.

The top is bumpy and
the bottom is round.

The leaves
grow upwards.

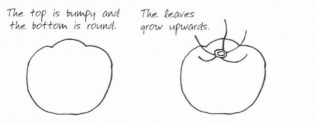

1. Draw the outline.

2. Draw the
guidelines for the
calyx and leaves.

3. Thicken the leaves
and color them black.

cabbages

*The word means "head" in French. Cabbage is said
to help maintain a healthy stomach.*

While drawing, try to
think of a sturdy and
heavy cabbage.

Be conscious of
the roundness.

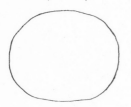
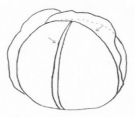
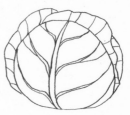

1. Draw a round outline.

2. Draw overlapping
leaves and the heart
of the cabbage.

3. Add the veins in the
cabbage leaves.

let's draw!

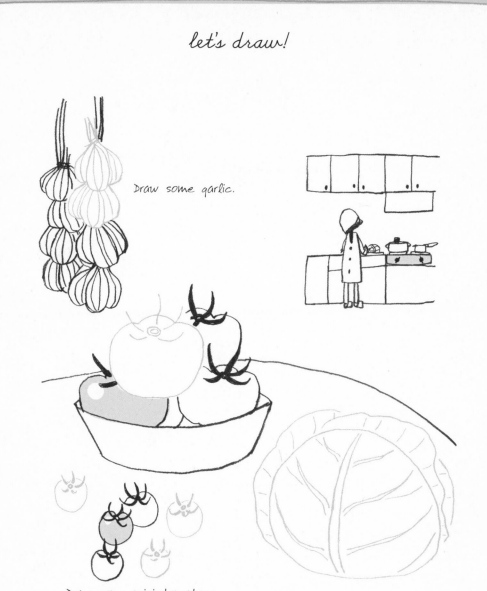

Draw some garlic.

Draw some mini-tomatoes.

corn

It is said that soon after being harvested, corn loses its taste and nutritional value.

Use guidelines to draw the ear of corn.

This is the fibrous part.

Each kernel of corn on the cob is connected, but simplify the picture in order to show the whole ear of corn.

Arrange the kernels alternately.

1. Draw a long, thin outline.

2. Draw the lines on the calyx at the base, the husk wrapping the ear of corn and the lines running along the cob.

3. Draw each kernel of corn and the bushy corn silk.

asparagus

In Greek, it has several meanings, such as "fresh bud" and "abundant harvest."

The leaves on the tip of the asparagus stalk are arranged alternately.

They are sparser toward the bottom.

1. Draw the outline of the stalk like a horsetail.

2. Draw the short, twisting leaves

3. Draw the lines on the leaves.

let's draw!

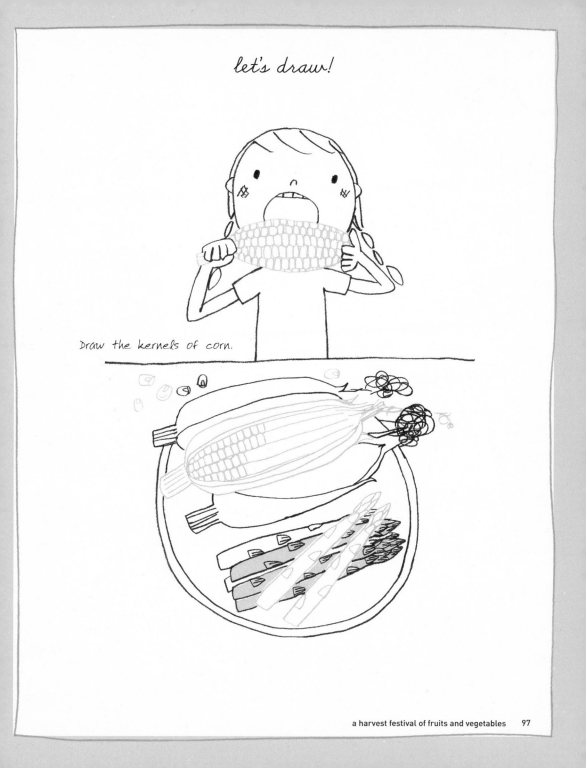

Draw the kernels of corn.

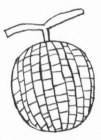

melons

Melons have a striking meshwork pattern, and the more distinct the pattern the more delicious the fruit.

The direction of the meshwork is determined by the positioning of the vines.

1. Draw the outline of the melon and the vines.

2. Draw the vertical lines of the meshwork pattern.

3. Draw the horizontal lines in the meshwork pattern.

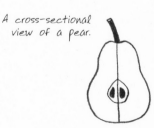

pears

If you keep pears for a while after they have been picked the taste and fragrance mature.

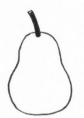

A cross-sectional view of a pear.

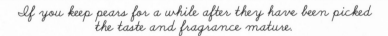

1. Draw the outline of a pear.

2. Draw the stem.

Draw a pear cut in half.

let's draw!

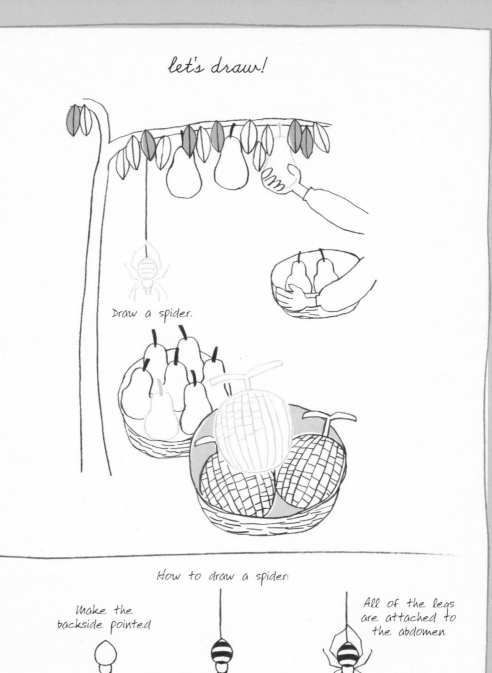

Draw a spider.

How to draw a spider:

Make the backside pointed

All of the legs are attached to the abdomen

illustrations on stationery

If you spend some enjoyable time creating special illustrations and add them to letters or cards, you can be sure that the recipients will definitely feel great pleasure as well.

Arranged in lines. Joined up. Repeated. Whatever method you follow, if you continue drawing the flowers and insects, it turns into a pretty design before you know it. Plants and insects are motifs that are often used. Why don't you try decorating the letters and cards you casually send with designs that you have created?

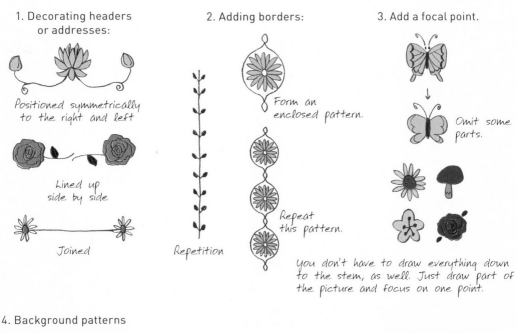

1. Decorating headers or addresses:

Positioned symmetrically to the right and left

Lined up side by side

Joined

2. Adding borders:

Repetition

Form an enclosed pattern.

Repeat this pattern.

3. Add a focal point.

Omit some parts.

You don't have to draw everything down to the stem, as well. Just draw part of the picture and focus on one point.

4. Background patterns

Snow

Rain

Starry sky

5. Letters and Cards with Designs

Patterns for letter paper should be created in a color that does not get in the way of the writing.

Add an elegant effect to cards.

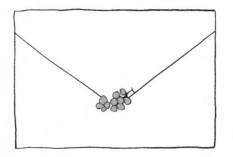

A small button-sized design as a seal on the envelope

Add a flower or plant design to notepaper and convey a sense of the season.

sketching on photographs

You can create really fun-filled cards by adding illustrations to photographs. You can draw directly on the photograph, but when there are difficulties, such as fitting all the drawings on the photograph, you can create an appealing effect by cutting out illustrations drawn on another piece of paper and creating a collage. When drawing the pictures, it is important to remember that they should fit into one part of the photograph.

Choose the kinds of colors that create an image of the actual subject matter.

Limit the number of colors.

Cut and paste pictures drawn on other paper.

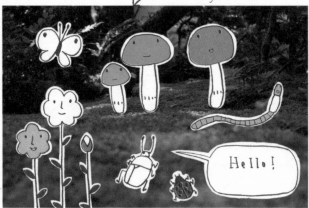

"Have a good trip!"

Draw directly on the photograph

"Enjoy your trip!"

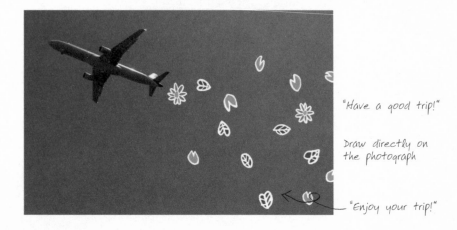

Draw directly on the photograph.

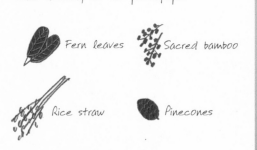

Fern leaves Sacred bamboo

Rice straw Pinecones

New Year's decorations are made using auspicious plants that bring good fortune.

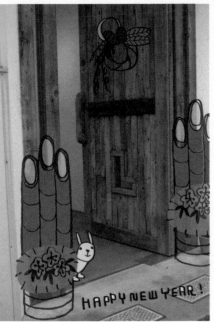

HAPPY NEW YEAR!
A Year of the Rabbit New Year's Card

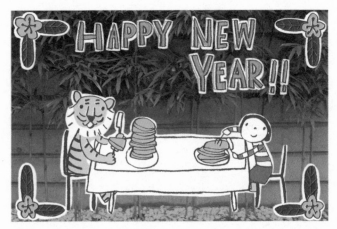

HAPPY NEW YEAR!
A Year of the Tiger New Year's Card

Cut and paste pictures drawn on other paper.

birthday and christmas cards

It is so heartwarming to celebrate Christmas or birthdays with special handmade cards. By using thick paper you can create special cards with your own designs. You can decide on the shape and size of the card yourself. Do not worry, even if it is a little crooked here and there; just enjoy the feeling of making something by hand.

birthday cake-shaped birthday card

Because many decorations are attached to the cake, it is better to keep the shape of each one simple. You can add more layers and make the card as long as you like. The letters in the words happy and birthday are aligned with the wavy edging.

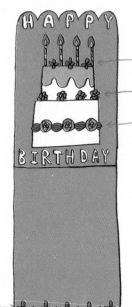

Color the design in a colorful way.

Add violet-shaped icing and raspberries

Rose decorations

Use the same flower pattern here as you used to decorate the cake.

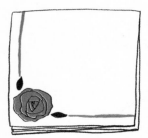

Draw a line from the leaves around the edge of the card.

Draw the borderline on the back and a secret message in the middle.

a birthday card decorated with a rose

Draw one rose flower in the corner and fold the card like a handkerchief. When it is opened the message is discreetly revealed. If you use a thin yellow pen to draw the line that runs around the edge of the card it will not be too bright and it will create a rather special effect.

a poinsettia card

Boldly draw a large poinsettia on a thick square card. Although the basic shape is clear-cut, it still appears quite calm-even when drawn large. Place a small illustration of a present, drawn with yellow lines, inside the card.

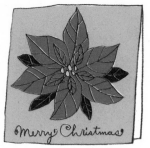

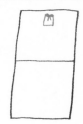

A tiny present illustration inside

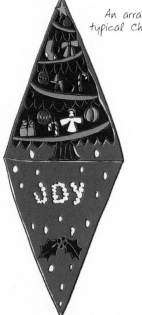

An arrangement of typical Christmas images

The illustration on the front is strawberry cake.

christmas tree card

This card has the special feature of a tree that appears when you open the card. First of all, draw the tree and then cut the card into a triangular shape, matching the shape of the tree. Draw some snow falling, decorate it with some holly, and draw some soft and fluffy lettering.

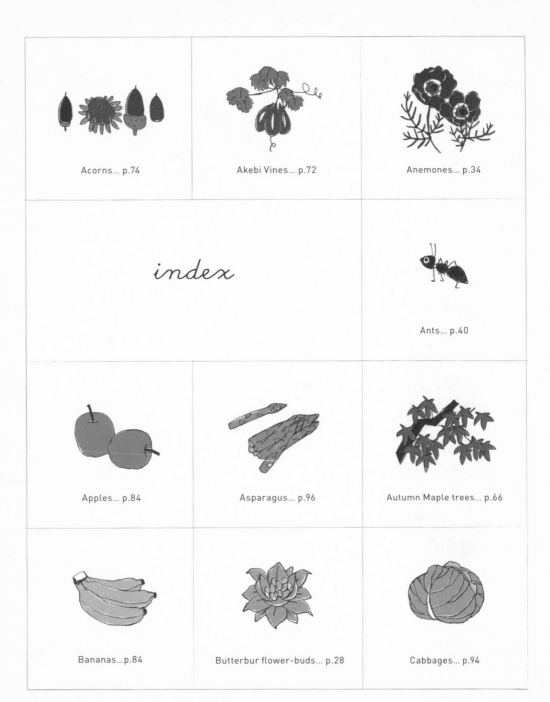

Acorns... p.74

Akebi Vines... p.72

Anemones... p.34

index

Ants... p.40

Apples... p.84

Asparagus... p.96

Autumn Maple trees... p.66

Bananas...p.84

Butterbur flower-buds... p.28

Cabbages... p.94

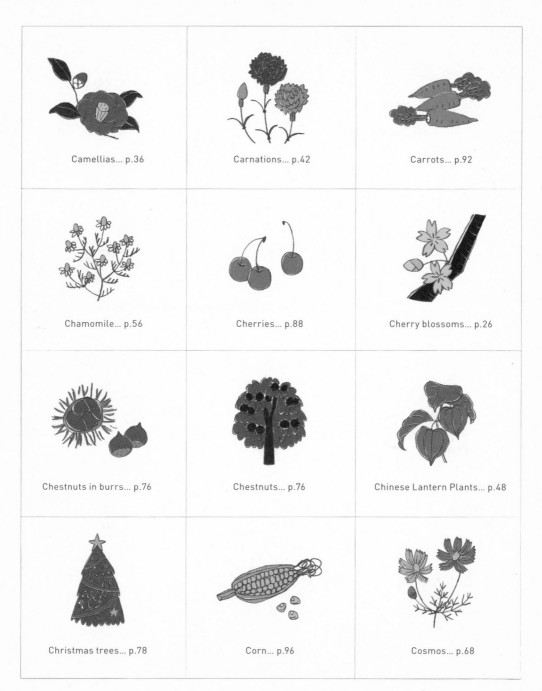

Camellias... p.36

Carnations... p.42

Carrots... p.92

Chamomile... p.56

Cherries... p.88

Cherry blossoms... p.26

Chestnuts in burrs... p.76

Chestnuts... p.76

Chinese Lantern Plants... p.48

Christmas trees... p.78

Corn... p.96

Cosmos... p.68

Daisies... p.30

Dandelions... p.40

Fireflies... p.64

Frogs... p.64

Ginkgo Trees... p.70

Grapes... p.88

Hibiscus... p.62

Hyacinths... p.34

Hydrangeas... p.50

Konara Oak Trees... p.74

Lavender... p.56

Lemons... p.86

Lilacs... p.38

Lilies... p.46

Lilies-of-the-valley... p.46

Maple trees... p.68

Marguerite... p.54

Melon... p.98

Morning Glory... p.58

Ornamental Carp... p.52

Palm trees... p.62

Pampas grass... p.70

Pansies... p.32

Pears... p.98

Peonies... p.36

Pineapple, A... p.90

Plum trees... p.26

Poinsettias... p.78

Poppies... p.42

Praying Mantis... p.48

Primroses... p.44

Pumpkins... p.92

Rape blossoms... p.26

Red Spider Lilies... p.72

Rhinoceros Beetles... p.60

Roses... p.38

Salvia... p.66

Stag Beetles... p.60

Strawberries... p.86

Sunflowers... p.58

Swallows... p.50

Swallowtail butterflies... p.44

Tomatoes... p.94

Tulips... p. 30

Violets... p. 32

Water lilies... p.52

Watermelon, A...p.90

Wild Strawberries... p.54

about the author

Sachiko Umoto graduated with a degree in oil painting from Tama Art University in Tokyo, Japan. In addition to her work as an illustrator, she also produces animation for USAGI·OU Inc. She is the author of *Illustration School: Let's Draw Happy People* and *Illustration School: Let's Draw Cute Animals* (both originally published in Japan by BNN, Inc.). She dearly loves dogs and Hawaii.

 Visit her online at http://umotosachiko.com.